A STUDY IN LIGHT

By

Vivian Grimes

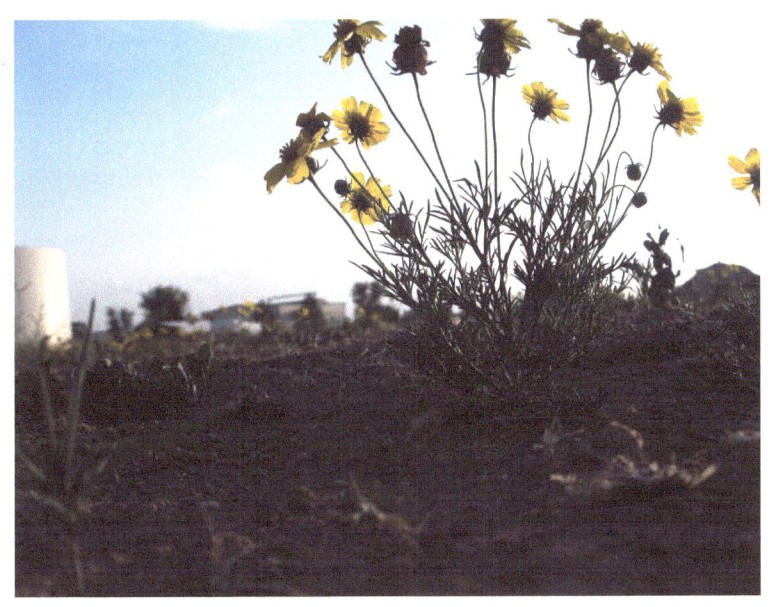

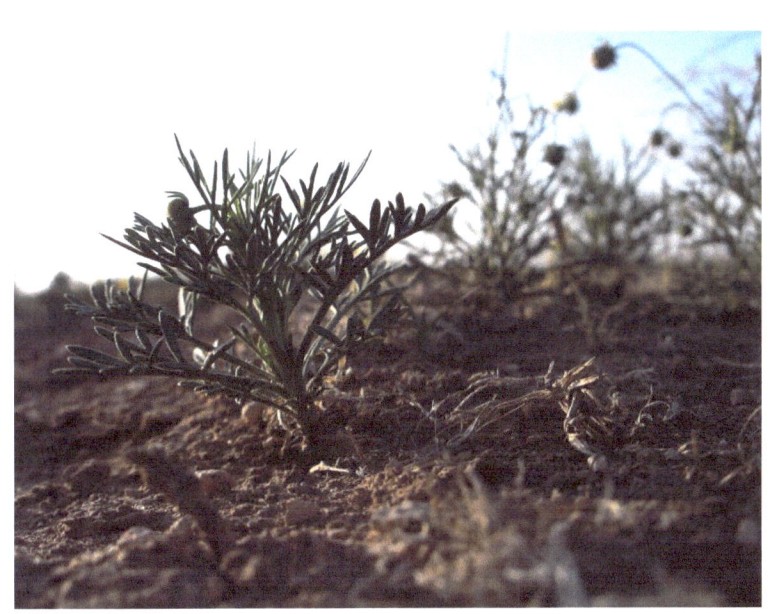

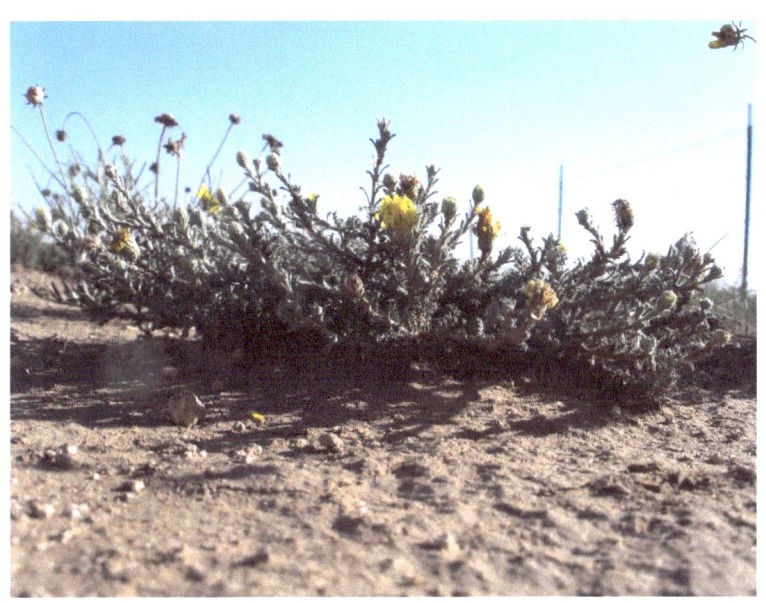

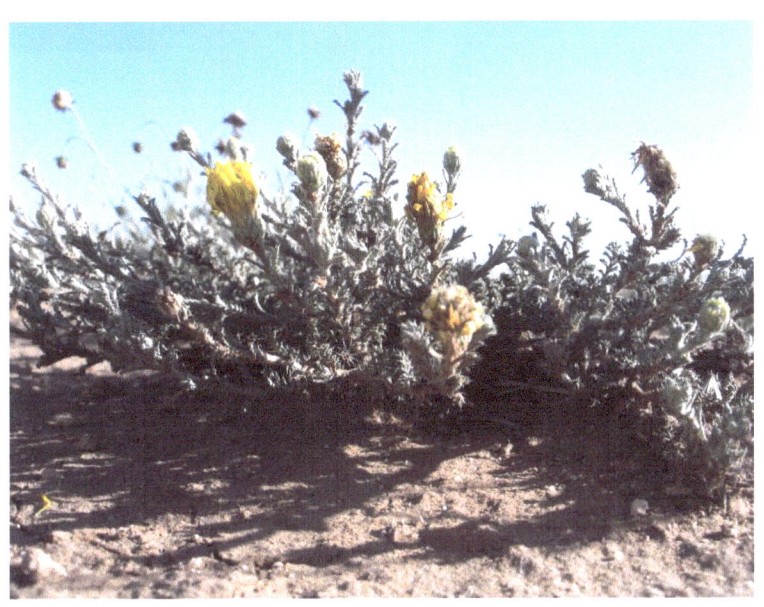

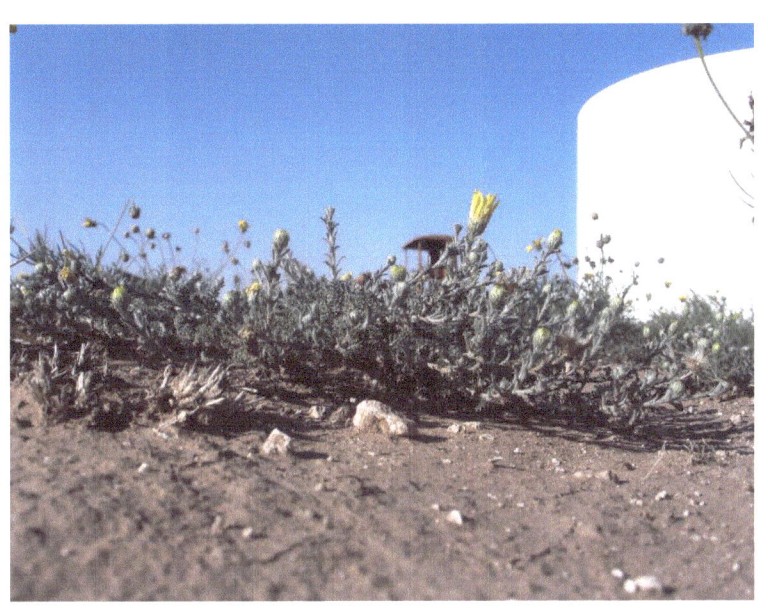

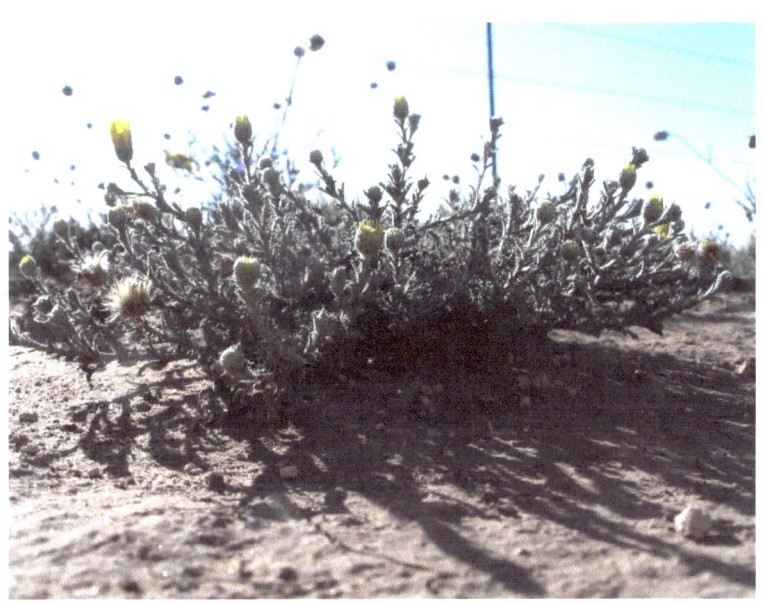

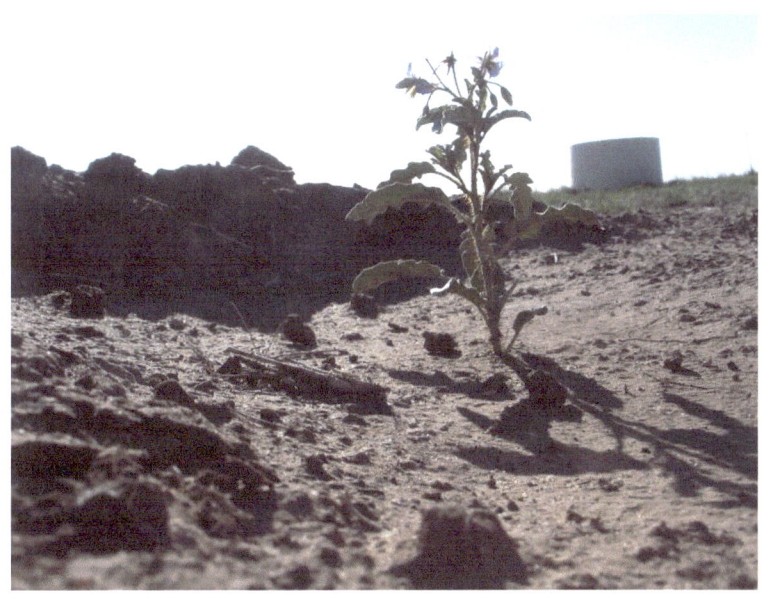

www.ingramcontent.com/pod-product-compliance
Lightning Source LLC
Chambersburg PA
CBHW041105180526
45172CB00001B/117